T Shirt Design Book

Design Your Own

Design Within the dotted square

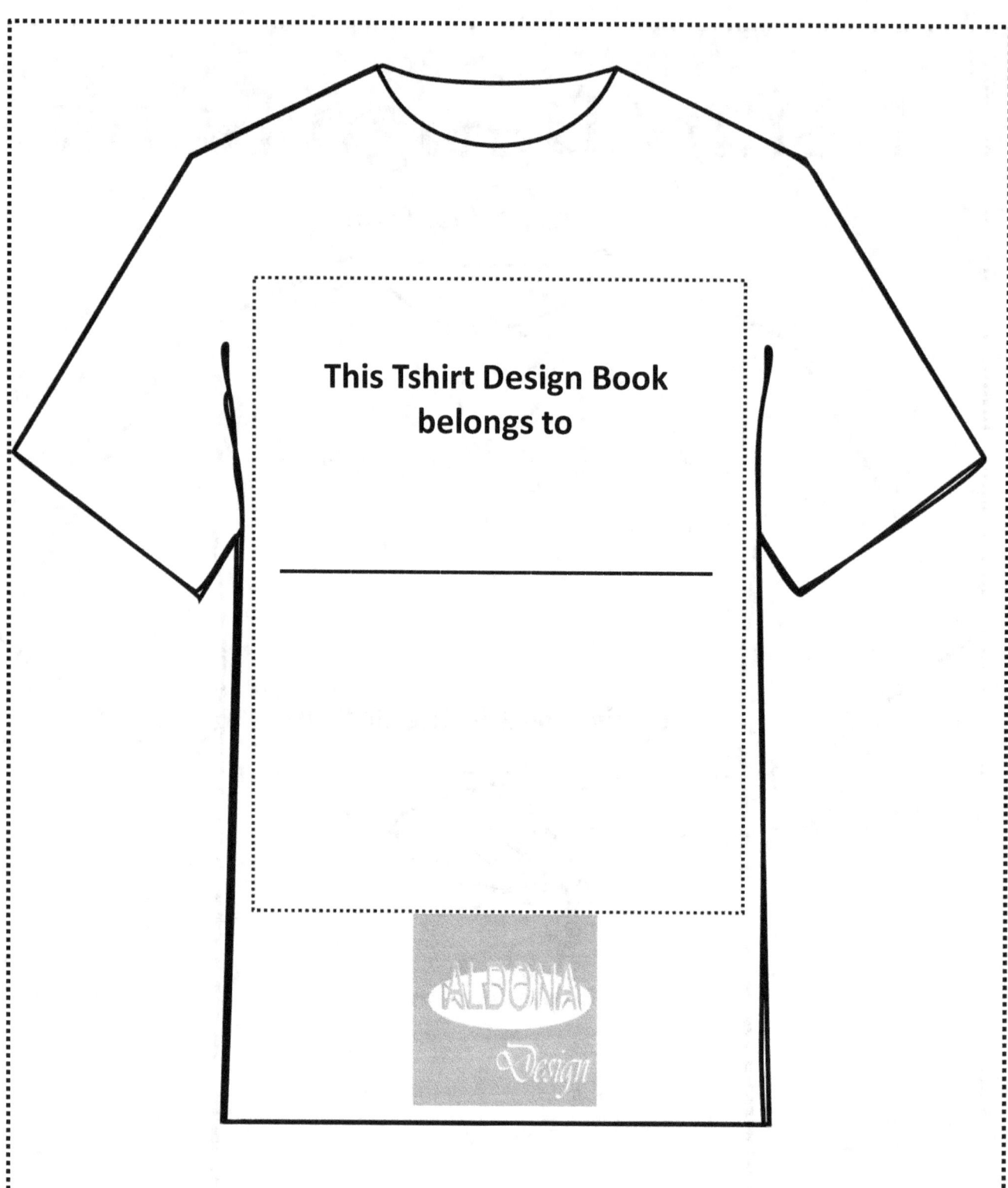

Copyright Aldona Design
All rights reserved, no part of this publication may be reproduced, stored in a retrieval system or transformed in any form or by any means of mechanical, electronic or photocopying, scanning or recording or otherwise without the permission of the Publisher/ Designer

We would like your opinion about this book by leaving a review on our Author page link as

amazon.com/author/aldonadesign

We would like your opinion about this
book by leaving a review on our
Author page link as

amazon.com/author/aldonadesign

Thank You

www.ingramcontent.com/pod-product-compliance
Lightning Source LLC
Chambersburg PA
CBHW080548220526
45466CB00010B/3078